KT-140-586

74613

BP PORTRAIT AWARD 2003

National Portrait Gallery

Published in Great Britain by
National Portrait Gallery Publications,
National Portrait Gallery,
St Martin's Place, London WC2H 0HE

Published to accompany
the BP Portrait Award 2003,
held at the National Portrait Gallery,
London, from 12 June
to 21 September 2003,
and at Aberdeen Art Gallery,
from 6 December 2003
to 15 February 2004.

For a complete catalogue
of current publications
please write to the address above,
or visit our website at
www.npg.org.uk

ISBN 1 85514 339 9

A catalogue record for this book
is available from the British Library.

Publishing Manager: Denny Hemming
Editor: Caroline Brooke Johnson
Design: Anne Sørensen
Production: Ruth Müller-Wirth
Photography: Prudence Cuming
Travel Award photography: Alan Dimmick
Printed and bound in Britain

Cover: *Below the Window* by Tim Millen

How do we judge a good portrait? By the likeness? By its technique? By the interest and richness of the painted surface? By a telling pose? All these play their part. But the most striking factor in the judging of the BP Portrait Award is that with few exceptions the sitters are unfamiliar to the judges, so the specific nature of the depicted person – and something of their personality and psychology – must be conveyed without the 'original' being available for comparison. This puts pressure on the judges to see where the final image conveys the relationship between artist and sitter, to scrutinise the work as a record of their time spent together – to search for the person in the finished painting.

Choosing from a record entry of 858 submissions has been a fascinating process and, for all of this year's judges, a pleasurable challenge. There are fifty-one outstanding portraits in the exhibition, forty-seven from the UK and four from other countries, with the artists roughly evenly split between those under thirty and those in their thirties. All four of the short-listed portraits are of an exceptionally high standard. And as we found in the disagreements and debates across the two judging days, there were many more submitted that could have been included in the exhibition in terms of their technical achievements or the appeal of the image; but only a few could be selected. A selection has to be made.

The rules for the 2003 Award were adjusted to emphasise two things. First, that this award is for painted portraits. Although drawing or photographic processes may play their part in the construction of the portrait, its creation must come out from and through paint. Secondly that it is important to know that the work was created from life, from some engagement with the person portrayed. There may be another place for fantasy portraits, or for portraits derived from photography, film, television or the web, but this competition is focused around the central place of the human image and the depiction of individuals. And it remains a competition to encourage younger artists, to support those under forty who are in the early stages of their careers as artists.

The range and extent of the work selected is wonderfully various. From large canvases, some with complex compositions and groups of people, to small canvases, almost like miniatures to be held in the hand, artists have chosen to picture their friends, lovers, colleagues, mothers, fathers and children. Many different stories emerge within the frame: from a picture of a film shoot to the stillness of a baby asleep, from a couple getting engaged via mobile phone to a critic portrayed in the National Portrait Gallery. Perhaps part of the enjoyment of these works is the sheer diversity of the subjects combined to make this exhibition. Given that very few of these are commissioned works, the patient friend or family member persuaded to give time and sit assumes a large and significant place within the overall selection, alongside the self-portrait.

Each year's exhibition leads on to several things. All exhibitors are offered the chance to submit a proposal for the BP Travel Award, which provides the opportunity for an artist to experience working in a different environment, in Britain or abroad, on a project related to portraiture. This year, selected portraits by Daisy Richardson and Jessica Wolfson will be exhibited following their great train journey across Russia and China, during which they painted some of the people they met. In addition the winner of each year's Award is offered a commission and collectively, these now form an important part of the National Portrait Gallery's contemporary collection. The boldness and brilliance with which Victoria Russell, for example, has engaged with the great actor Fiona Shaw demonstrates how this competition supports artists who have a long-term contribution to make in recording those leading or influencing our cultural and social history.

Ultimately much of what is so telling in these works relates on the one hand to the physical depiction: the colour, tone, shadow, surface and intensity of the painted work, whatever the style, from expressionist to hyper-realist, and whatever the medium, whether oil or acrylic. On the other hand, through this depiction, there is the possibility of finding the emotional, psychic or even spiritual dimension that A.S. Byatt delicately

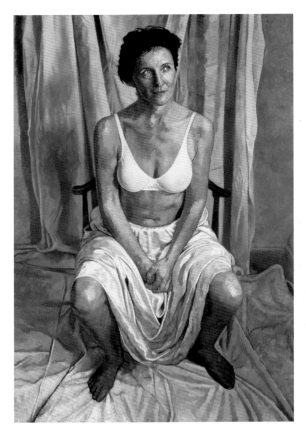

WINNER'S COMMISSION, 2000
FIONA SHAW,
b.1958
Victoria Russell, 2002
Oil on canvas,
1828 x 1220mm
(72 x 48")
National Portrait
Gallery (NPG 6609)

explores in her essay. As she expounds it, this form of revelation may be the final compelling reason for the importance and persistence of the contemporary painted portrait in a world over-crowded with photographic and digital images.

SANDY NAIRNE
Director, National Portrait Gallery

FOREWORD

BP recognises the role that arts and culture play in the economic and social fabric of the country. We maintain a focus on excellence and our social investment programme includes support for some of Britain's most outstanding cultural institutions, including the National Portrait Gallery.

Over the twenty-two years since it was established the BP Portrait Award has demonstrated once again the artistic potential of figurative art. The growth in the number of entrants, from across the United Kingdom and abroad, and in the number of visitors to the exhibition, is encouraging evidence of the role of the Award in developing the understanding and appreciation of portraiture.

BP is delighted to have been associated with the Award over the last thirteen years and we are very happy to be able to continue our partnership with the National Portrait Gallery for at least another four years. The skill and commitment of the Gallery's staff have turned what began as a small and experimental project into a sustained, internationally recognised success. Our thanks are due to them and, of course, to the artists whose ability to capture human character on a two dimensional canvas is a rare and precious quality.

LORD BROWNE OF MADINGLEY
Group Chief Executive, BP

INFORMATION ABOUT THE BP PORTRAIT AWARD

The BP Portrait Award, now in its twenty-third year at the National Portrait Gallery and thirteenth year of sponsorship by BP, is an annual event aimed at encouraging young artists to focus upon and develop the theme of portraiture within their work.

Many artists who have had their work on show have gained commissions as a result of the considerable interest aroused by the Portrait Award.

The entire competition is judged from original paintings and is followed by an exhibition of works selected from the entries. Since 1990, the competition has received over 600 entries annually, out of which an average of fifty paintings a year have been exhibited.

The competition is open to artists from around the world aged between eighteen and forty. The entry must be in oil, tempera or acrylic, and should be painted from life with the human figure predominant. A full list of rules and an entry form can be obtained from: BP Portrait Award, National Portrait Gallery, St Martin's Place, London WC2H 0HE.

Recent winners of the Portrait Award and their resulting commissions include Tomas Watson (1998) who painted *John Fowles*, Clive Smith (1999) who painted *Sir Ian McKellen* and Victoria Russell (2000) who painted *Fiona Shaw*.

Why, in the age of photography, film and digital images, are we still interested in painted portraits? Their function as a public record of what important people look or looked like – which is part of the idea of a National Portrait Gallery – has to some extent been taken over. Good modern public portraiture is quirkier and more idiosyncratic than portraits were in the past – the need to make mnemonics both of physiology and of dignity is less.

Yet portraits are always about recognition – even when we are looking at someone we know only from the image in front of us. We learn to read images of bodies and faces. One fascination of the difference between photographs and paintings is fascination with the different means of exciting recognition.

The ability to recognise and distinguish human faces seems to be organised into the early workings of our brains. Very small babies respond to smiley faces on paper circles as they do not respond to blanks. Psychological experiments on perceptions of symmetry, and ideals of beauty, suggest that there are templates of the arrangement of facial features – distances between eyes, between brow and mouth – that experimental subjects prefer. There are portraits that represent very simply those elements by which we distinguish one face from another, or from an ideal – the political cartoon, or the minimal masks in Matisse's print of his own face with those of Apollinaire and Cocteau, where there are just enough marks to make oval frame, eyes, nose and mouth, and exact proportion is everything.

What distinguishes painting (or drawing or etching) from photography as a record of recognition is the artists' personal choice of notation of their observation – and the arrangement of the marks with which they record it. Our response to painting and drawing is as much to the artist and the artist's choices as to the depicted person and their form and nature. This could, I know, be said of photography too – indeed most of the public is probably better equipped to judge the complexity of photographers' aesthetic choices than to understand the variety of possible styles and devices

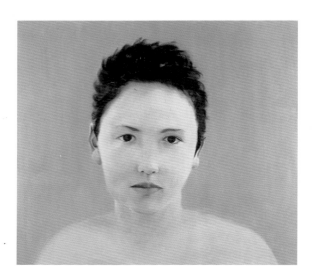

from which a painter chooses both at the beginning of a work, and at every moment of its construction. There is so very much that can be done with paint that what we are offered for our contemplation seems always startling when we consider all the other ways we might have seen this particular human being.

I wrote of the recognition of essential shapes in Matisse's masks. Somewhere at the other end of our preoccupation with human forms is the preoccupation with the rendering of the surface of flesh by a surface of paint. The recording gaze can be chilly analytic, or erotic – or both at once. We are amazed by Lucian Freud's expanses of naked rolls and crevices partly at least because we respond to the intensity of his staring – every gradation of colour, every flicker of change made by shadow or vein or flush finding a painterly skill to turn it into a skin of colour on canvas. Such precision is exciting and unnerving in an age when we have learned to admire the flourish of impression or the bravura of expressionism. Flesh is equally present in Frank Auerbach's portraits, though the process by which we recognise it is entirely different. Auerbach's portraits are three-dimensional layers of paint, in and

through which the form and presence of the sitter can be recognised – oddly like an insubstantial ghost in a very substantial apparent chaos of matter. You can look at the rich sheen of paint, or step back and be confronted by the look (in both senses) of the sitter. And the flicker of your eye and mind between paint and the idea of flesh is the pleasure of the portrait.

Painters paint flesh – portraits and ideal visions – for erotic reasons. The erotic gaze can produce Titian's golden surfaces, or De Kooning's female forms looming in chaos and strain, or Matisse's harmonies of *peignoir*, relaxed limbs, and delicious pinks and violets, or Balthus's closed and exposed nymphets. In *Le chef-d'oeuvre inconnu*, Balzac's imaginary painter, Frenhofer, (with whom Cézanne identified himself) paints a woman who is perceived by onlookers as a formless mass of shifting and misty marks. Frenhofer describes the process by which he made the 'real woman' both as a process of stroking and caressing her into being with his brush, and as a rendering of the 'conjunction' of light and matter, the place where paint meets canvas, where light meets and defines flesh. More modern painters have written of 'painting with the penis'.

Recognition in the case of painted portraits is always double – we are recognising both sitter and painter. We know not only that this is the face of Henry VIII but that it is 'a Holbein' or 'a Quentin Matsys'. We know a Gainsborough from a Reynolds, a Rembrandt from a Franz Hals – we recognise problems and solutions of arranging light and matter, as well as human interests and presumptions, sometimes shared by painter and subject. There is a family resemblance between Watts's contemplative Victorian 'great men', ambitious and modest at once, as there was, Proust remarked, between Whistler's women – in that case, Proust sagely points out, this is also because such portraits are a record of their time and its subtle preoccupations as to fashion. Certain bits of the body, certain parts of the face, are exaggerated or idealised. Flattery, like visual analysis, erotic pleasure or disgust, is part of the cultural atmosphere in which portraits are made. As are

pity, contempt and humour. Picasso caressed, mocked, raped, butchered, dominated and exploded the women who sat to him, whether partners or models. We respond to the energy of all these intentions, as much as to the cat-like complacency of one woman, or the outraged howl of another.

Early artists' photography – as is most clear from the work of Julia Margaret Cameron and its relation to Victorian painting – saw its templates very much in terms of painted portraits, and what those had been used to describe. Costume, mood, lighting, were very obviously and artificially constructed to make pictures with meanings. Modern painters, faced with the camera's greater facility in recording the flesh and bones and proportions – and even expressions – of human faces and bodies, turned away from mimesis. Some successful portraits drew on other styles of notation – the simplicity and energy of children's drawings of face and stick legs, the fined-down and exaggerated forms of masks and icons.

I am very interested in those painters who paint with and against photography. I think particularly of Gerhard Richter, who began by reproducing in paint images from snapshots taken at random from a box – he has said that his interest is simply in paint, and in what it can do. He makes a painterly record of the visual effect of photography (and at some deep level of the cultural shifts it has effected in our lives, also). Later he began to paint very 'beautiful' portraits, taken from, and resembling, slightly blurred photographs – representing, for instance, a woman with a lovely face in profile, in the colours (in paint) of colour photography. He also painted a monumental series of paintings of the photographs of the Baader Meinhof Gang, in death and in life, icons for our time, differing from the photographs partly at least because of the contemplative time put in by the artist. He had lived with these images, and made paintings of what he saw. They are paintings of what photography records.

I do not think one can take the difference between photography and painting too far. One can recognise a

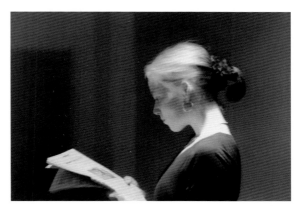

Cartier-Bresson, or a Diane Arbus, quite as clearly as one can recognise a Modigliani or a Matthew Smith. I think, oddly, the difference is partly in what is done to the object of the work of art – in the case of portraits, I have come over the years to feel that there was some sense in the response of surprised 'natives' to the early photographers. They believed that photographs were theft – that something had been taken from them. If you sit to a photographer, the shutter clicks, and the chemistry of light on film 'takes' you – takes your face as it was then, for that moment, and already is not and will never be again. It is a small miracle, and our world is full of its products. Photographs are always of the past, and in some sense, of the dead, or if we are living, of our approaching death. Whereas paintings are someone's attempt to understand and represent – what? Light on matter, the human form, your body at this moment in time and space – the soul?

We are uneasy these days with souls. We are happy with personalities, and also with Personalities and celebrities. But we find it harder than ever to talk or write about the essential self, which can be seen to be looking out of many painted faces (or out of imaginary windows, or modestly down, or into a painted book . . .). We know when it is there. But secondary abstract words used to describe its nature – 'fierce', 'courageous', 'seductive', 'wary', 'honest' – seem always to reduce

the impact of the whole complex painted presence. And once descriptions wander into fancied narrative, they depart from describing the paintings. Ford Madox Ford was quite right to generalise about Holbein's great lords, and say they were indoor, sedentary, cunning rulers, not knights in armour – but these words do not describe the sensations we have when we recognise and consider their faces. We get closer if we try to work out why Rembrandt was so good at rendering eyes that he could *choose exactly* how to render a particular pair of eyes, their age, their focus, their energy of regard, or the lack of it. We talk about how painters 'capture' or 'catch' expressions, and the souls behind them – we even use the metaphor of 'arresting' the movement of the appearance of the spirit in the flesh. Catching with a paintbrush, and arresting in paint, is (to be a little fanciful) different from successive 'takes' of a face exposed to light and shadowed on silver or celluloid. The soul of a photographed person is his or her own, even if sneaked up on, or surprised. The soul of a painted person is what the painter has made of what he or she has seen.

People make facile comparisons between written and painted portraits, but the differences are more interesting, even when we are thinking about the early stages of composing visual likenesses in the mind. We have learned not to represent our perceptual processes with the image of a homunculus or demon in the head painting a picture that we then 'read' with our 'inner eye'. We know that we make up images from widely separated parts of the brain – and that the word 'green' doesn't come from the part that perceives greenness but from the part that stores words and their associations.

Both kinds of portrait may be extended into the things that appear in the portrait with the person. Saints and angels have iconic attributes – the Virgin's lily, St Lucy's eyes in a dish. Rulers have gold, silver and sceptres, or, like Elizabeth I, a sieve or an ermine as a physical representation of a spiritual quality. Portraits from less symbolic ages can contain a dish, an egg, a

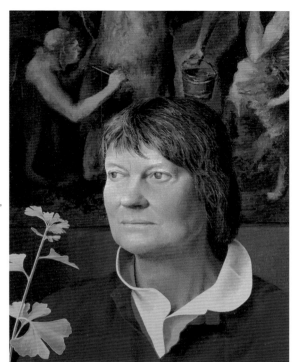

DAME IRIS MURDOCH,
1919–99
Tom Phillips, 1984–6
Oil on canvas,
914 x 711mm
(36 x 28")
National Portrait
Gallery (NPG 5921)

bed, a lighting-scheme, that represent aspects of the person painted – even a carefully selected landscape background. Written portraits may use metaphors, or associations, to build up an image – but the essence of that image is that it is not solid, it is not arrested, it is fluid. A good writer who describes a human being knows that every reader will make an inner representation of that described being – *and that they will all differ* – and that they will probably differ slightly every time any reader re-reads the description. Whilst a painting is *there*, it is a material object, which was once not there and now is.

Which is not to say that writers can't describe pictorial metaphors, or that painters can't describe the world of writers – in their own terms. Proust's descriptions of the brush-strokes in his imaginary Elstir's

portraits of his wife, and of Odette, know how brush-strokes can make metaphors, lace as foam, a shirt-front in one sentence as snow, as lilies-of-the-valley, as a garden of crisp flowers, a velvet jacket as pearly, as cat-fur, as dishevelled like the ragged edge of carnations. Tom Phillips's portrait of Iris Murdoch in the National Portrait Gallery is a portrait of Murdoch's writerly world – a face not addressing herself to the onlooker, but looking up and out, a background of a great and terrible painting that meant a great deal to the writer, Titian's *Flaying of Marsyas*, a riddle about the terror of art, a battle between form and formlessness. And a real and metaphorical ginkgo, a fresh green shoot, from the novelist's garden, of the oldest living tree form. The whole painting is a portrait of the novelist, Iris Murdoch. But the fact of her presence, the presence of a person, has to be seen, not described.

A.S. BYATT
Novelist and critic

BP PORTRAIT AWARD 2003

This year the Portrait Award received 858 entries. Five judges took two days to choose four prize winners and a further forty-seven portraits to be exhibited at the National Portrait Gallery and Aberdeen Art Gallery.

THE JUDGES

Des Violaris, Director, UK Arts and Culture, BP

Catherine Goodman, Winner of the BP Portrait Award 2002 and Director of The Prince of Wales's Drawing Studio

Baroness Helena Kennedy QC, Chair of the British Council

Cathy de Monchaux, Artist

Sandy Nairne, Director, National Portrait Gallery

THE PRIZE WINNERS

First Prize
Charlotte Harris who receives £25,000, plus a commission worth £3,000 to paint a well-known person

Second Prize
Michael Gaskell who receives £8,000

Third Prize
Graham Flack who receives £4,000

Fourth Prize
Dean Marsh who receives £1,000

PRIZE-WINNING PORTRAIT

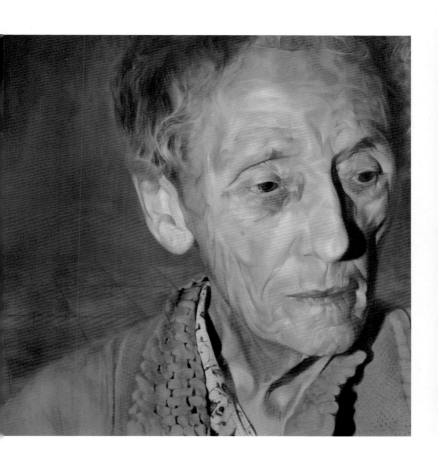

FIRST PRIZE
UNTITLED
Charlotte Harris
Oil on canvas, 1220 x 1225mm (48 x 48¼")

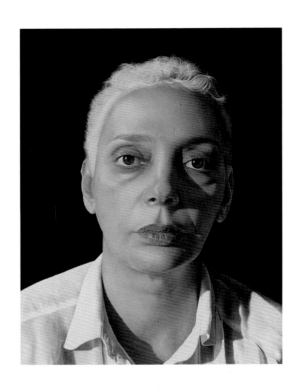

SECOND PRIZE
NOURA
Michael Gaskell
Tempera on board, 450 x 380mm (17^{3}/$_{4}$ x 14^{7}/$_{8}$")

22

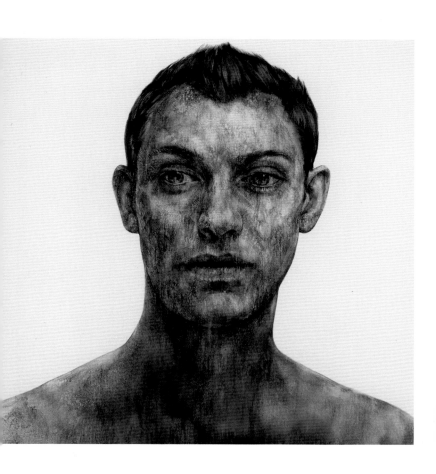

THIRD PRIZE
ELLIOT II
Graham Flack
Oil on canvas, 1560 x 1560mm (61$\frac{1}{4}$ x 61$\frac{1}{4}$")

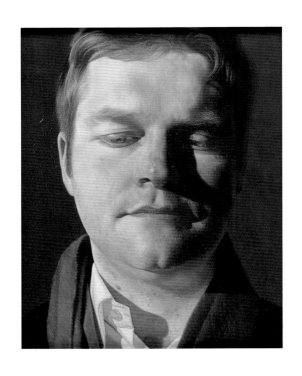

FOURTH PRIZE
MAN WITH GREY SCARF
Dean Marsh
Oil on board, 335 x 285mm (13$\frac{1}{8}$ x 11$\frac{1}{4}$")

SELECTED PORTRAITS

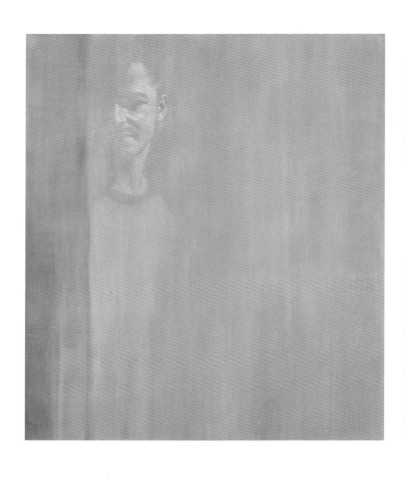

KYLE'S REFLECTION
Jackie Anderson
Oil on canvas, 1070 x 905mm (42¹/₈ x 35⁵/₈")

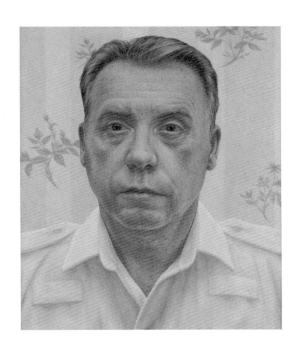

PORTRAIT OF MY FATHER
Daniel Barry
Oil on board, 400 x 349mm (15^{3}/$_{4}$ x 13^{3}/$_{4}$")

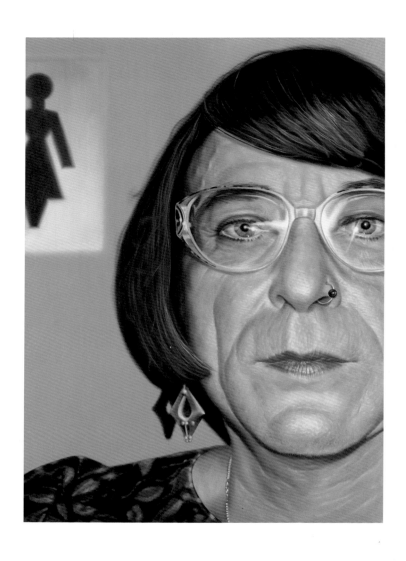

FRANK/ALICE
Graeme Brooks
Oil on canvas, 1884 x 1348mm (74$\frac{1}{8}$ x 53$\frac{1}{8}$")

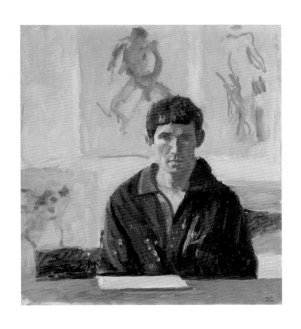

SELF-PORTRAIT
David Caldwell
Oil on canvas, 540 x 500mm (21$^{1}/_{4}$ x 19$^{3}/_{4}$")

29

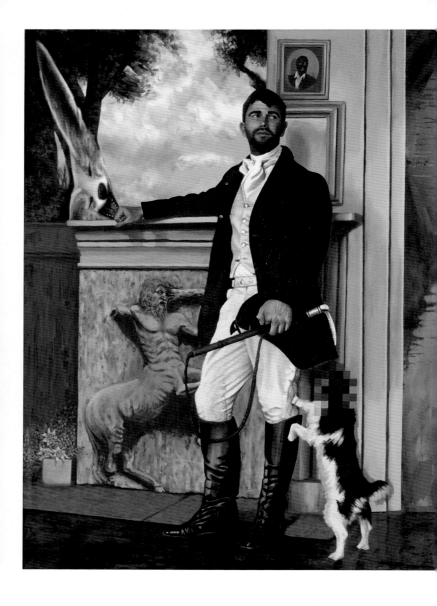

UNTITLED (PORTRAIT OF IVAN MASSOW)
Darren Coffield
Acrylic on linen, 1530 x 1230mm (60^{1}/$_{4}$ x 48^{1}/$_{4}$")

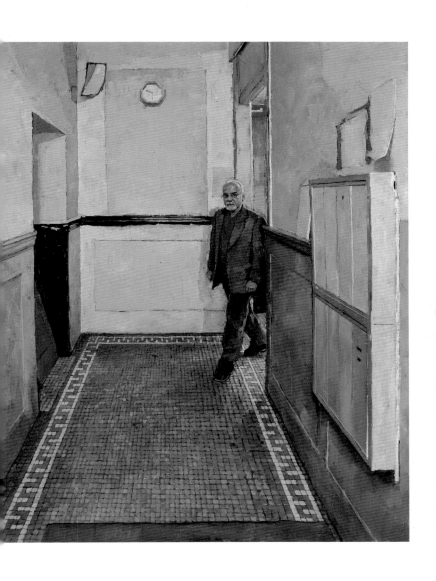

CRAIG LEAVING STUDIO
R.A. Combes
Oil on canvas, 1415 x 1160mm (55³/₄ x 45⁵/₈")

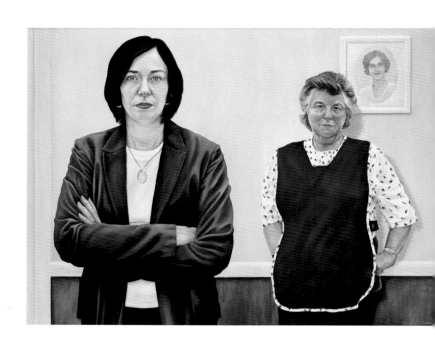

FEMALE LINE
Mark Cook
Oil on board, 1015 x 1320mm (39⁷/₈ x 51⁷/₈")

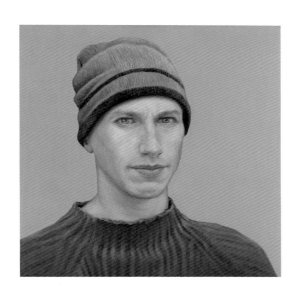

SELF-PORTRAIT
Gabriel Corcuera-Zubillaga
Oil and acrylic on canvas, 410 x 405mm (16^{1}/$_{8}$ x 15^{7}/$_{8}$")

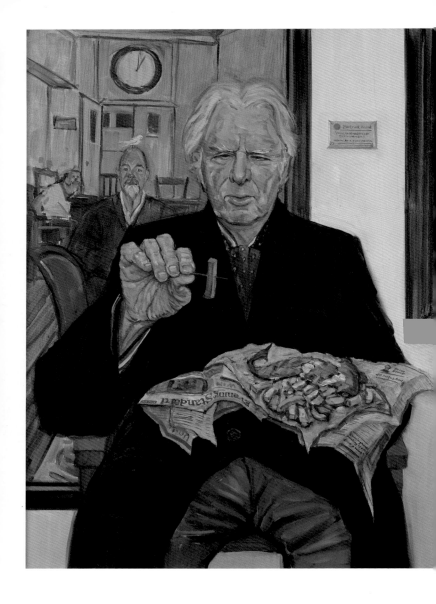

BRIAN SEWELL *TODAY'S REVIEW,
TOMORROW'S FISH & CHIP PAPER*
Kevin Cunningham
Oil on canvas, 1360 x 1050mm (53¹/₂ x 41¹/₄")

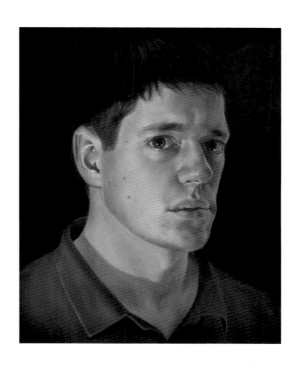

SELF-PORTRAIT
Samuel Dalby
Oil on canvas, 635 x 532mm (25 x 20$^7/_8$")

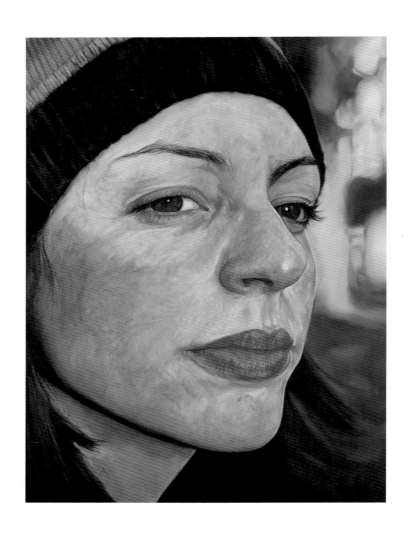

SELF-PORTRAIT
Kelly-Anne Davitt
Oil on canvas, 1200 x 900mm (47¹/₄ x 35¹/₄")

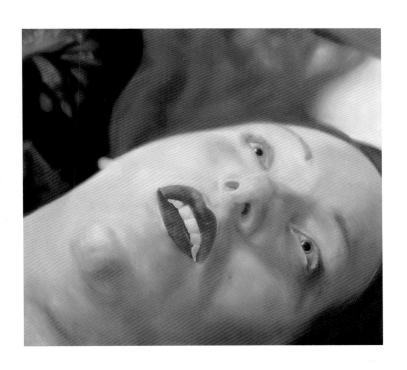

KATE
Paul Denton
Oil on canvas, 1000 x 1100mm (39$^{1}/_{4}$ x 43$^{1}/_{4}$")

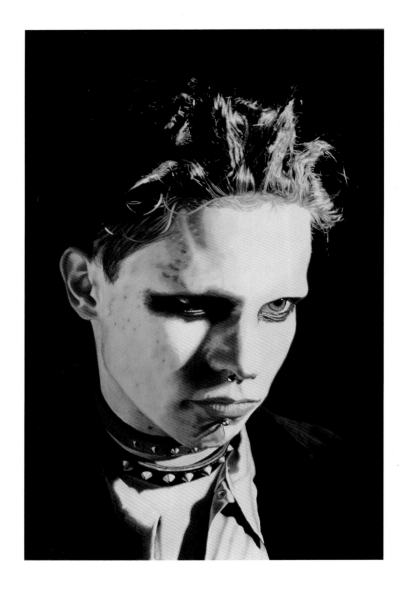

#4 (SELF-PORTRAIT AFTER A WEEK'S SLEEP
DEPRIVATION FINISHING A PAINTING FOR THE BP AWARD)
Juno Doran
Oil on canvas, 1840 x 1220mm (72$^1/_2$ x 48")

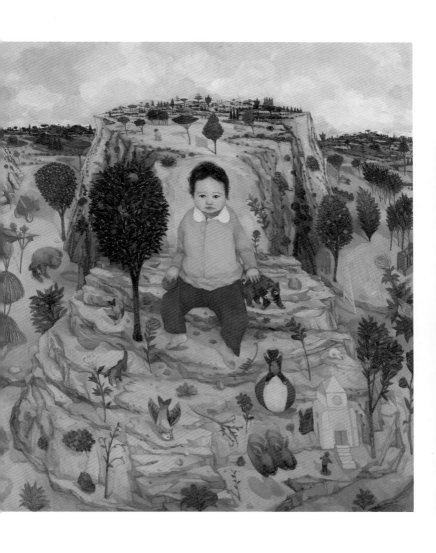

MAISY
Joe Fan
Oil on canvas, 1600 x 1370mm (62$^{7}/_{8}$ x 53$^{7}/_{8}$")

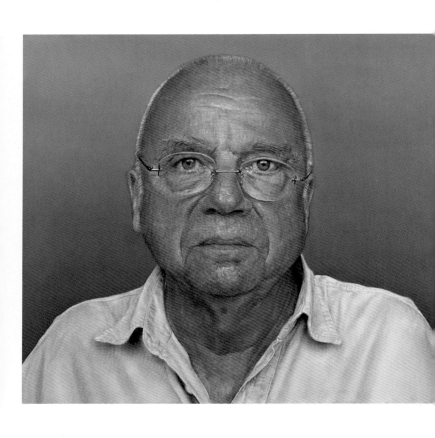

PETER
Frank Föckler
Acrylic on canvas, 1100 x 1250mm (43¼ x 49¼")

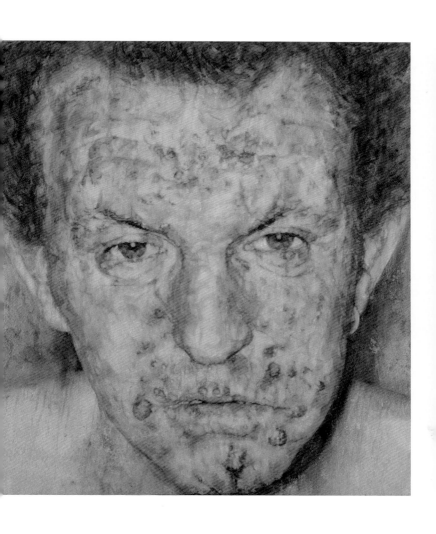

FRED
Vasiliki Gkotsi
Oil on canvas, 1840 x 1635mm (72¼ x 64¼")

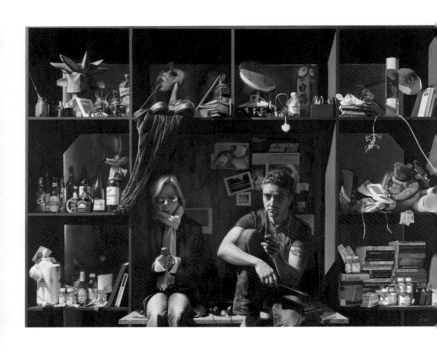

(SENDING MESSAGE): BE MY WIFE
Mitch Griffiths
Oil on canvas, 1960 x 2575mm (77⅛ x 101¼")

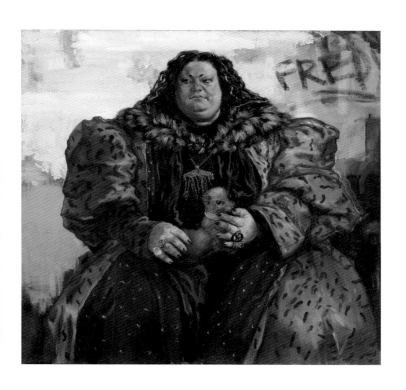

FREDDY
Ulyana Gumeniuk
Oil on canvas, 980 x 1035mm (38^{5}/$_{8}$ x 40^{3}/$_{4}$")

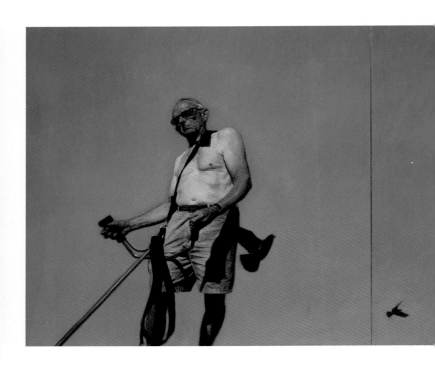

RIVER ROAD
Phil Hale
Oil on linen, 1380 x 1730mm (54¼ x 68⅛")

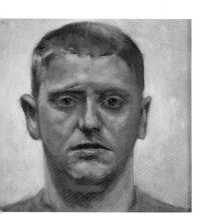 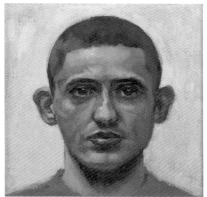

D & G (DIPTYCH)
Caspar Hall
Oil on board, 325 x 323mm each (12³/₄ x 12²/₃")

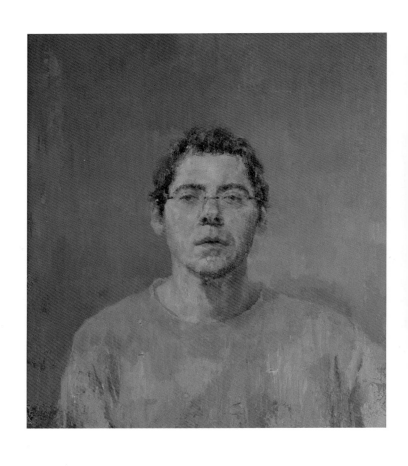

SELF-PORTRAIT
Jaemi Hardy
Oil on panel, 670 x 588mm (26¼ x 23⅛")

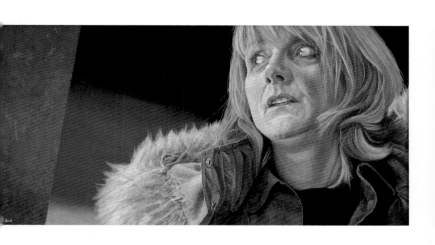

BÊTE NOIRE
Craig Hawker
Acrylic on board, 430 x 730mm (16$^{7}/_{8}$ x 28$^{3}/_{4}$")

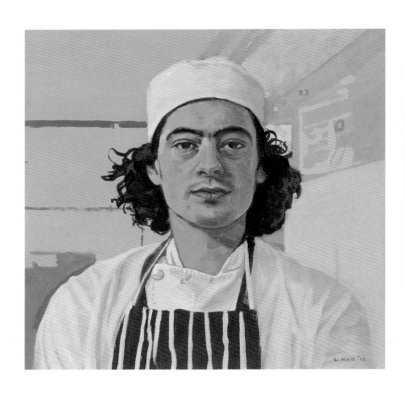

ANDREW THE CHEF
Laurence Kell
Acrylic on board, 590 x 600mm (23$\frac{1}{4}$ x 23$\frac{5}{8}$")

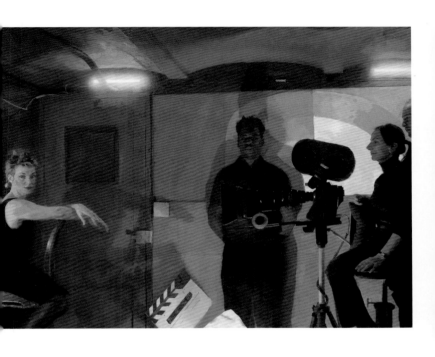

THE ACTRESS
Brendan Kelly
Oil on canvas, 1370 x 1825mm (53$^{7}/_{8}$ x 71$^{7}/_{8}$")

UNTITLED (TOM CONRAN)
Matthew Usmar Lauder
Acrylic on board, 857 x 610mm (33³/₄ x 24")

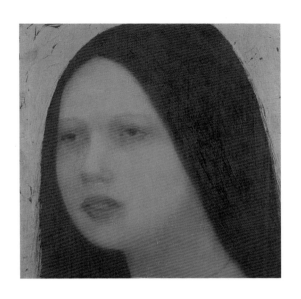

ELLEN
Jane MacNeill
Oil on board, 332 x 330mm (13$^{1}/_{8}$ x 13")

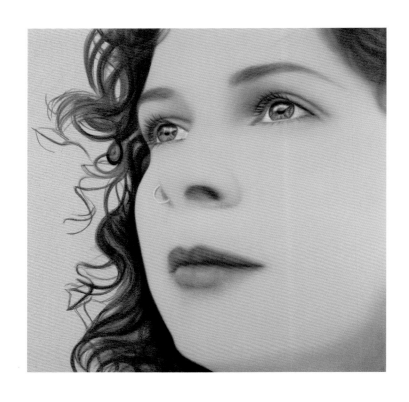

SARAH PILMER
Josie McCoy
Oil on canvas, 600 x 600mm (23^5/$_8$ x 23^5/$_8$")

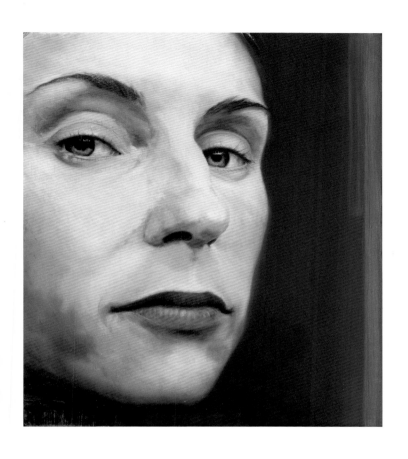

BELOW THE WINDOW
Tim Millen
Oil on canvas, 549 x 488mm (21⅝ x 19¼")

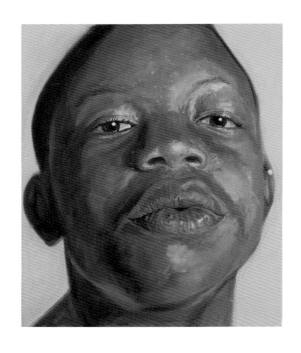

DAYNE: YR.8 (WRENN PORTRAIT NO.9)
Peter Monkman
Oil on canvas, 310 x 258mm (12$\frac{1}{4}$ x 10$\frac{1}{8}$")

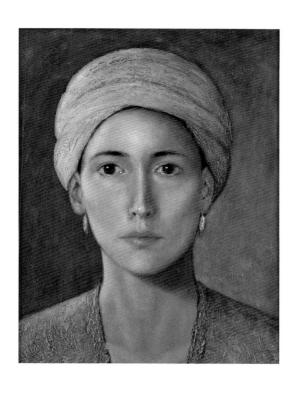

GOLDEN TURBAN
Nanne Nyander
Oil on board, 575 x 455mm (22⅝ x 17⅞")

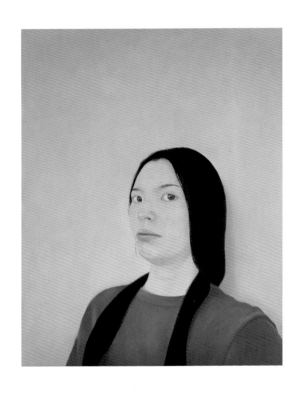

SELF-PORTRAIT
Yuka Omura
Oil on canvas, 610 x 455mm (24 x 17⁷/₈")

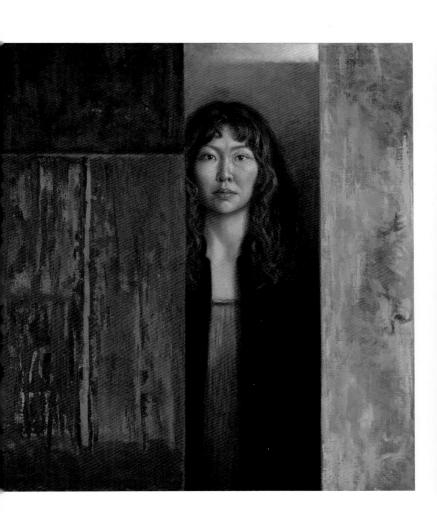

SELF-PORTRAIT (MY INHERITANCE)
Anna Hyunsook Paik
Oil on canvas, 1070 x 970mm (42⅛ x 38⅛")

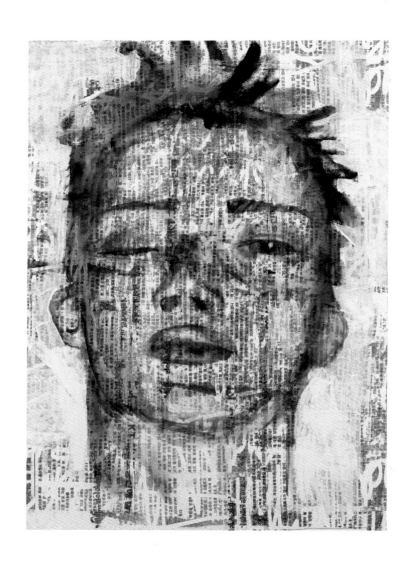

UNTITLED
Anne-Laure Ponsin
Acrylic on canvas, 1190 x 850mm (46^{7}/$_{8}$ x 33^{1}/$_{2}$")

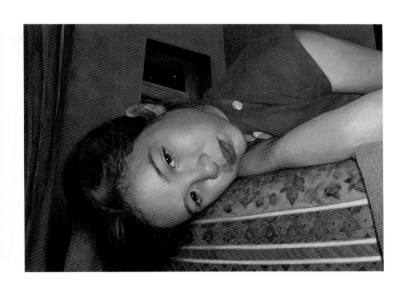

TAFFY TV
Emily Porter-Salmon
Acrylic on canvas, 500 x 700mm (19³/₄ x 27⁵/₈")

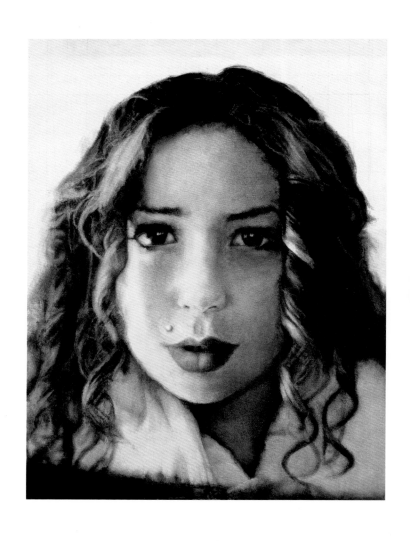

VICKY
Michael Roberts
Acrylic on canvas, 1200 x 900mm (47¼ x 35¼")

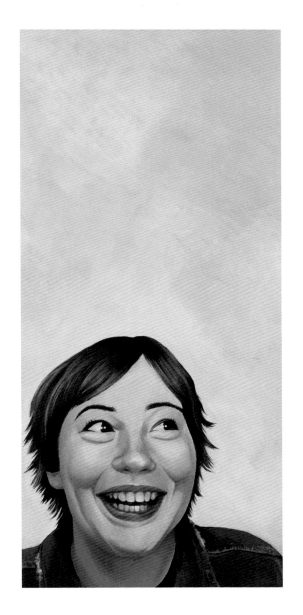

YES
Laura Sian Russell
Acrylic on board, 455 x 253mm (17^{7}/$_{8}$ x 10")

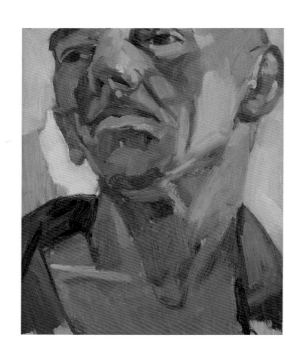

EDDIE
Kim Scouller
Oil on board, 470 x 420mm (18^1/$_2$ x 16^1/$_2$")

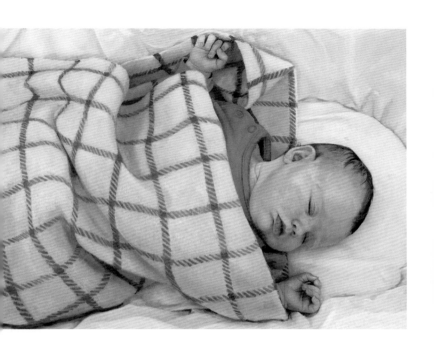

MORGAN KELLY
Blaise Smith
Oil on panel, 910 x 1210mm (35^{7}/$_{8}$ x 47^{5}/$_{8}$")

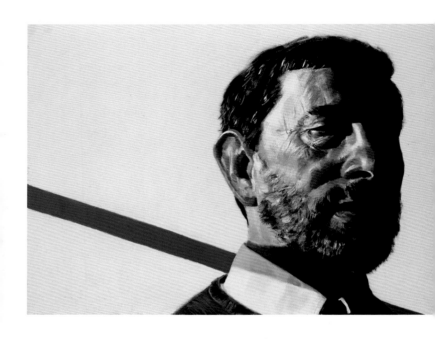

THE RT HON. DAVID BLUNKETT
Lorna Wadsworth
Oil on canvas, 870 x 1200mm (34^1/$_4$ x 47^1/$_4$")

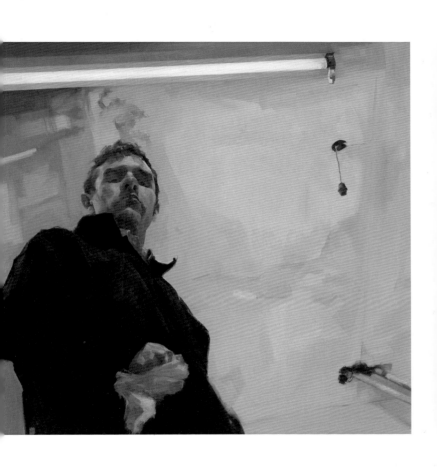

SELF-PORTRAIT, POSTMAN
Jason Walker
Oil on canvas, 1050 x 1050mm (41¼ x 41¼")

65

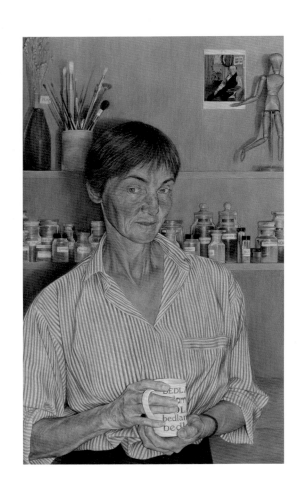

LIBBY SHELDON
Emma Wesley
Acrylic on board, 1210 x 755mm (47⁵/₈ x 29³/₄")

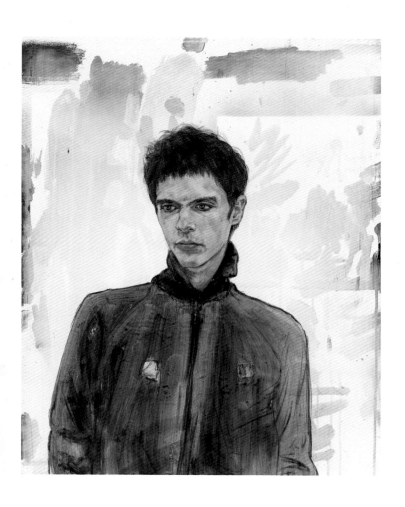

DAN IN MY STUDIO
Ian Whitfield
Acrylic on canvas, 797 x 645mm (31^1/$_4$ x 25^3/$_8$")

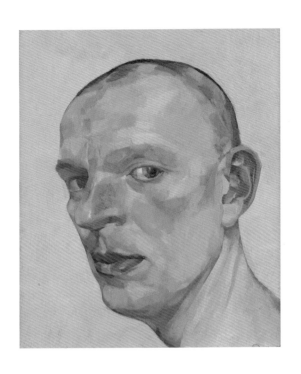

JACK
Toby Wiggins
Oil on canvas, 330 x 275mm (12^{7}/$_{8}$ x 10^{7}/$_{8}$")

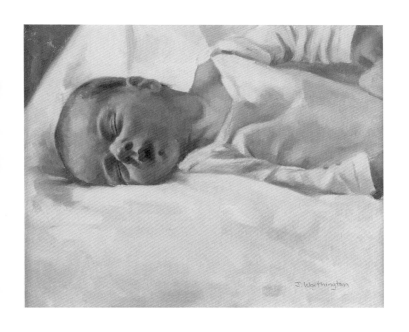

MILO
John Worthington
Oil on canvas, 390 x 435mm (15$\frac{1}{4}$ x 17$\frac{1}{8}$")

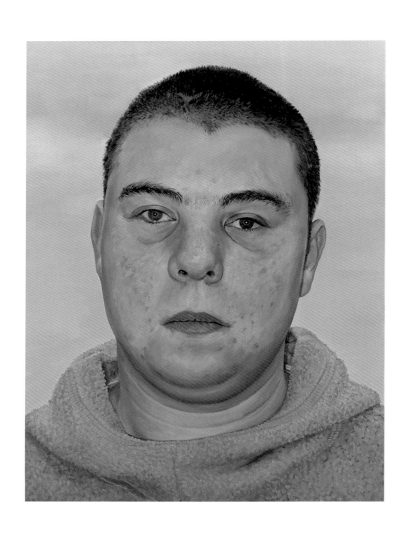

UNTITLED
Cindy Wright
Oil on canvas, 1705 x 1280mm (67^1/$_8$ x 50^1/$_4$")

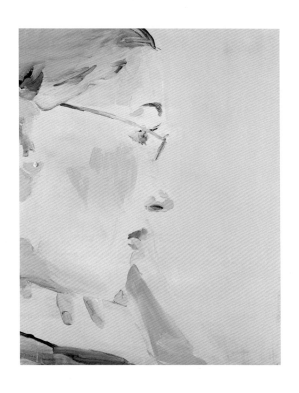

DAWN
Victoria Wright
Acrylic on canvas, 610 x 460mm (24 x 18$^1/_8$")

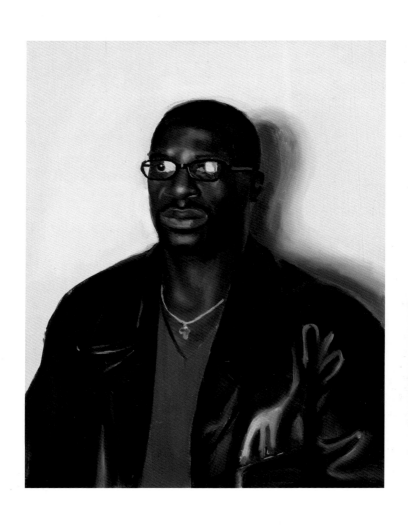

GEORGE
Paul Wuensche
Oil on canvas, 1075 x 875mm (42¼ x 34½")

BP TRAVEL AWARD

Jessica Wolfson and Daisy Richardson were joint winners of the 2002 BP Travel Award for their proposal to travel on the Trans-Siberian Railway, painting the people that they would meet along the way.

On 5 March 2003, full of expectation, they set off from Glasgow on a six-week journey. Stopping first at Krakow in Poland, they took the train from Warsaw to Moscow, where they caught the Trans-Siberian Railway to Irkutsk in Siberia. From there they travelled by local train to Ulaan Bataar in Mongolia, and then on to Beijing and Shanghai in China.

Both Daisy and Jessica painted with the subject in front of them – sometimes using their two-berth compartment as a studio – and worked mainly in oils. Wherever they travelled, they felt very conspicuous since each had to wheel around a specially designed box about the size of a fat briefcase, in which to store and dry their paintings. The boxes had shelves inside as oil can take up to a week to dry in cold climates.

The following portraits and diary extracts, selected by the artists themselves, introduce us to some of the people they encountered.

JESSICA WOLFSON'S DIARY EXTRACTS:

14 March
On the Trans-Siberian Railway
Lena was the second person we painted through our cold-calling method, after having nineteen refusals. She was a *provodna* (carriage attendant) on the train and she shared the job with her boyfriend, one slept while the other worked.

Lena was calm, beautiful and patient as sitting for us normally took much longer than we said, especially the 'last five minutes'.

As she watched us paint, I had a confidence crisis as all I wanted was to please her, to thank her for sitting and for her patience, but the more I tried, the worse it got. So at a point I had to stop wanting it to be good and just paint. I was surprised with the results, and since then liked it for all these reasons.

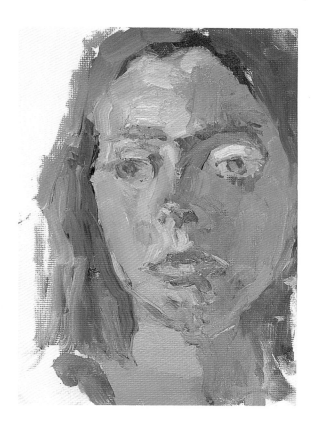

ENA
essica Wolfson
l on paper,
72 x 124mm,
$^3/_4$ x 4$^7/_8$")

5 April
Beijing
We painted Meishi in an advertising office in Beijing. This was arranged through Nick, a very tenuous link of Daisy's. We both received so much help from people who were friends of friends of people we did not really know in the first place.

Meishi was the husband of Apple; they were a young trendy couple with a child. We painted Apple first and then Meishi, using different colours from my usual palette, which can make things confusing. Meishi was also an artist so he drew us while we painted his wife. He had a fantastic and unusual face and curly hair.

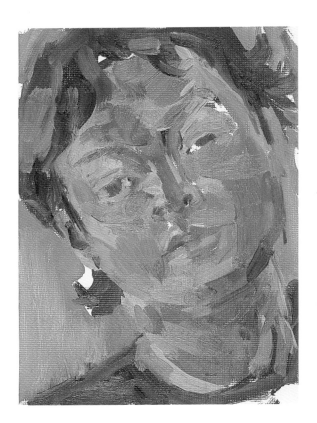

MEISHI
Jessica Wolfson
Oil on paper,
172 x 124mm,
(6³/₄ x 4⁷/₈")

DAISY RICHARDSON'S DIARY EXTRACTS:

25 March
Ulaan Bataar
We tagged on to the end of a tour of some artists' studios and ended up staying for hours after everyone else had left, painting and drinking Mongolian vodka, which is pretty good stuff. We painted one of the artists, Baiaar in his studio, and then his friend Che Batsetseg, who is a soldier. She put on some lipstick, rearranged her hat and sat very still, staring sternly at Jess the whole time. She has an excellent face and I enjoyed painting her. Painting these portraits has been a great way of get-

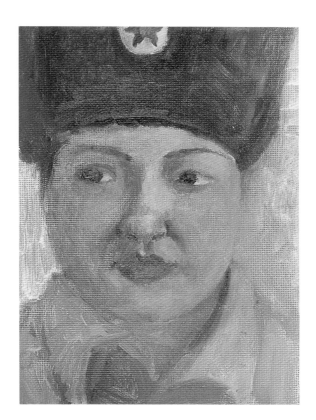

THE BATSETSEG
Daisy Richardson
Oil on paper,
172 x 124mm,
(6³/₄ x 4⁷/₈")

ting to know people you would never normally get to know. And you end up doing everyday things like sitting around at –5° C next to the river in Irkutsk painting with everybody on their mid-afternoon drinking session or hanging around doing exercises.

1 April
Beijing
We tried to go to the Temple of Heaven park but got lost and ended up in a different park instead. We climbed up big stone steps, passing flowering magnolia trees to a pagoda. Chinese park music was being continually piped through a variety of park orifices. The sky was

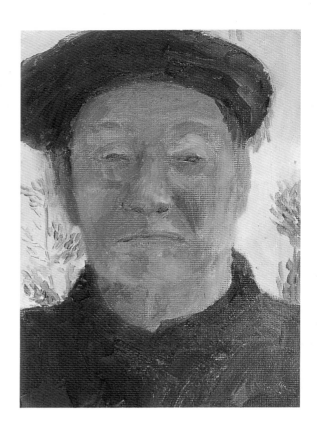

MR LIU
Daisy Richardson
Oil on paper,
172 x 124mm,
(6³/₄ x 4⁷/₈")

white, the trees were green and you could see for miles.
We sat down to draw and the second we took out our
sketchbooks, we were surrounded by an audience of
ten or fifteen. This happens quite often, which can be
a bit intimidating if you're doing a rubbish painting but
is also fun as you feel you're providing good entertain-
ment for everybody.

After a couple of drawings I asked a man called Mr
Liu to sit for us and he agreed, sitting motionless for
ages. He had the kind of face that looked as if he's seen
a lot. He was quite pleased with his paintings and
tucked the polaroids we gave him away into his wallet
before saying goodbye and heading off down the hill.

ACKNOWLEDGEMENTS

I should like to thank my fellow jurors: Des Violaris, Catherine Goodman, Baroness Helena Kennedy QC and Cathy de Monchaux. They provided excellent debate and made shrewd assessments in the face of enough good work to fill a much larger gallery. I am grateful to BP for their continuing support and Lord Browne for his personal interest and enthusiasm.

I would also like to thank Kathleen Soriano, Pim Baxter, John Haywood, Beatrice Hosegood, Claire Everitt, Sarah Howgate, Hazel Sutherland, Caroline Brooke Johnson and Anne Sørensen who, with many other colleagues in the Gallery, have done so much to make the Award as successful as it continues to be.

We are both honoured and delighted that A.S. Byatt should have accepted our invitation to write for this year's catalogue.

SANDY NAIRNE
Director, National Portrait Gallery

PICTURE CREDITS

INDEX